WELCOME

to the

Stock Show

M. JEAN GREENLAW

DUTTON **LODESTAR BOOKS** NEW YORK

For Lee Bennett Hopkins,
who made me write books.
Your "stock" is always high with me!

Library of Congress Cataloging-in-Publication Data
Greenlaw, M. Jean.
Welcome to the stock show/M. Jean Greenlaw.—1st ed.
p. cm.
Includes bibliographical references (p.48).
Summary: Follows three families as they raise their animals
for showing at the annual livestock show.
ISBN 0-525-67525-6 (alk. paper)
1. Livestock exhibitions—Juvenile literature. 2. Livestock—Showing—
Juvenile literature. 3. Southwestern Exposition and Livestock Show—
Juvenile literature. 4. Livestock exhibitions—Pictorial works—
Juvenile literature. 5. Livestock—Showing—Pictorial works—Juvenile
literature. 6. Southwestern Exposition and Livestock Show—
Pictorial works—Juvenile literature.
[1. Livestock exhibitions.] I. Title.
SF117.3.G74 1997
636.08'11—dc21 96-47810 CIP AC

Published in the United States by Lodestar Books,
an affiliate of Dutton Children's Books,
a division of Penguin Books USA Inc.,
375 Hudson Street, New York, New York 10014

Published simultaneously in Canada
by McClelland & Stewart, Toronto

Editor: Virginia Buckley Designer: Barbara Powderly
Printed in Hong Kong First Edition 10 9 8 7 6 5 4 3 2 1

ACKNOWLEDGMENTS

The pleasure in researching this book was meeting the wonderful people who gave of their time and knowledge. I would like to thank the children and their families, who graciously allowed me to tag along, call, and fax; who read and edited manuscript copy; and who taught me so much: Sarah Erwin, her sister Molly and brother Charley, and her parents Carol and Roy; Daniel Simpson, his sister Katie, his parents Anne and Danny, his uncle Robert Davis of J.F.D. Farms, and his grandfather J. Fred Davis Jr.; Sarah Griffeth, her sister Sam(antha), and her parents Cindy and Larry. In addition, there is a big thanks to Delbert Bailey, Publicity Manager for the Southwestern Exposition and Livestock Show in Fort Worth, Texas, who shared his expertise and gave me entry to the show for three years; and Tamara Taylor of Patteran Herd, a judge licensed by the American Dairy Goat Association.

CENTENNIAL

1896

FORT WORTH STOCK SHOW

1996

WELCOME to the stock show! All through the year, boys and girls as well as adults raise animals for participation in shows. Some of these events are huge, like the Southwestern Exposition and Livestock Show in Fort Worth, Texas. As many as three million people attend in January and February over seventeen days. This was the first stock show in America. It began more than one hundred years ago when several ranchers met for a day under a tree in Fort Worth and discussed how to improve and protect their cattle. Denver, Colorado, and Houston, Texas, also have enormous stock shows. If you attend a state fair, you will find a stock show among the attractions.

Most shows are held at county fairs and are much smaller. Or there may be exhibitions of animals of one type, such as rabbits or dairy goats. There are open shows, where children and adults compete at the same time, and junior shows, where only youths are in the event.

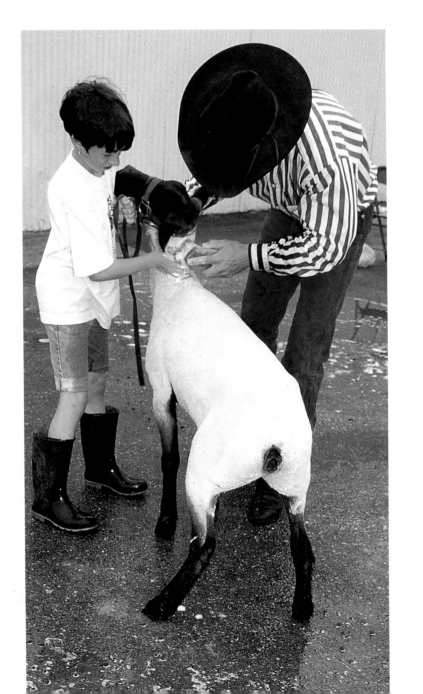

A stock show is filled with sounds, smells, and action. It is fun to watch the animals being bathed and clipped. Some are groomed with a special vacuum cleaner. Because there is usually straw or sawdust in their pens, smaller animals are often covered with a body stocking to keep them clean. As you walk around the show, you will see contestants waiting to go into the arena, others practicing their roping style, and Future Farmers of America (FFA) members holding animals so you can pet them. Exotic animals like llamas might even be in the barn.

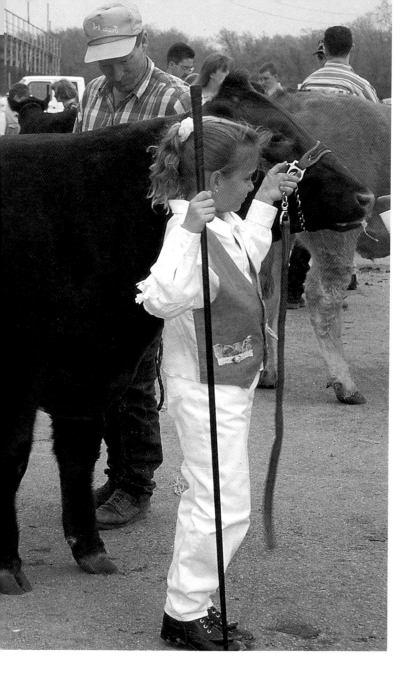
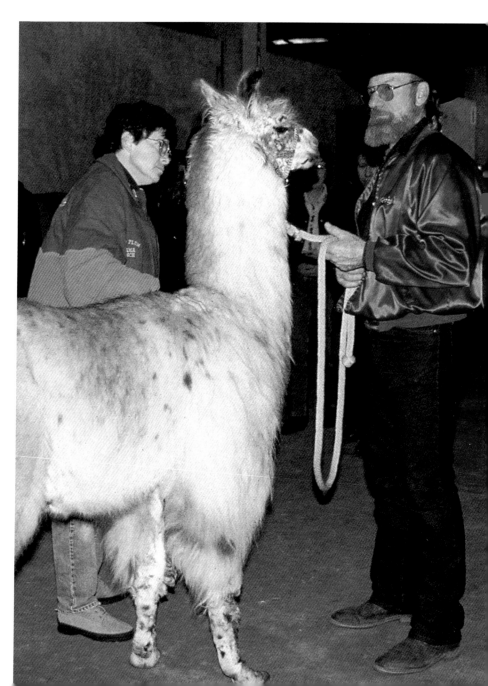

It is important to remember, however, that the main purpose of a stock show is to improve the quality of the stock being bred and shown. Agriculture is an industry, and there are specific features that a judge looks for in evaluating the animals of any type or breed. The prizes that are awarded are not just for hanging on a wall so that the contestant can feel special. They are to let potential buyers know that this is quality stock. People spend much time looking at the winners to see what is outstanding about them. Usually there is also an opportunity to buy animals.

Tamara Taylor, a judge licensed by the American Dairy Goat Association, describes how a judge becomes licensed and what he or she looks for in a competition. "A judge of dairy animals must spend years in training. Each year, we attend classes and take tests for two days. It takes twelve years before a judge can become fully licensed. After that, we need to attend a training session only once a year. Judges have a scorecard and must be able to see animals in the same way," she says.

She describes the difference between judging animals and judging participants. "Dairy animals are judged for their dairy character, not just for good looks but for physical soundness. An animal should be structurally sound and able to produce milk over a long lifetime. We judge the contestants for showmanship. Again, there is a scorecard, and we watch how the child handles the animal. Is the child in control and able to set up the animal properly? We look to see if the contestant has kept the animal well groomed and conditioned, and whether the animal seems to be alert. The appearance of the child is also important, and we ask them questions about their animals."

IN THE FOLLOWING PAGES, you will meet Sarah Erwin, Daniel Simpson, and Sarah Griffeth, who are very serious about raising quality animals and participate in many shows throughout the year.

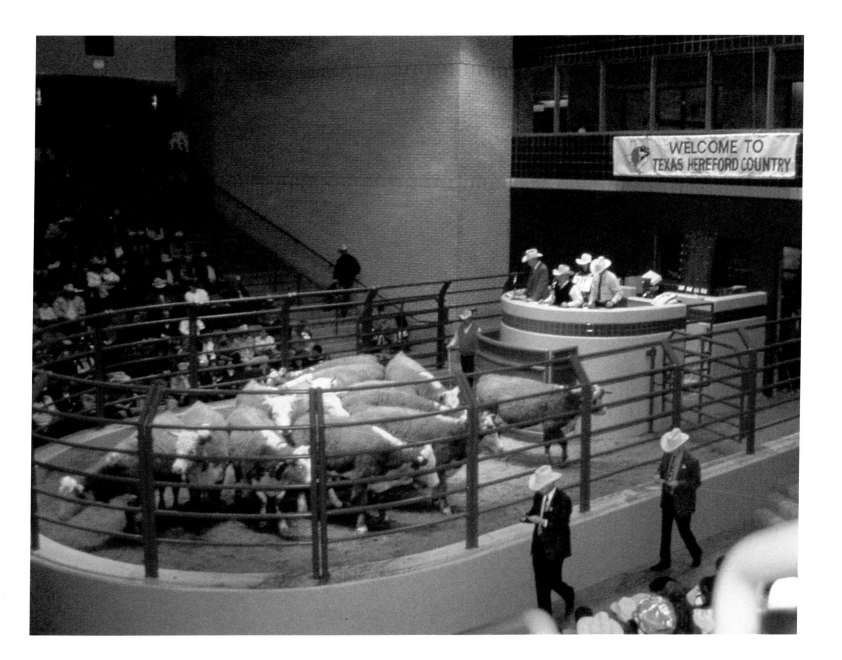

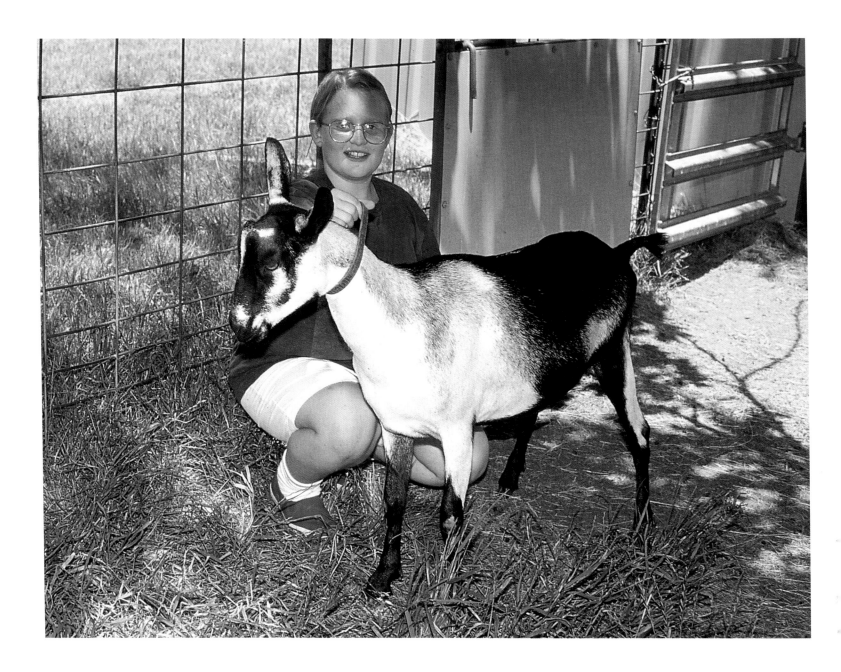

Sarah Erwin

SARAH ERWIN is president of the Sanger, Texas, 4-H Club and has been a member since she was eight years old. She emphasizes that 4-H is a family organization, with parents attending meetings. "The purpose of 4-H is to motivate and teach children how to care for their animals and how to compete successfully. Everyone helps, and though there is friendly competition at stock shows, there is also pleasure when friends win an award. When you are working with animals, you learn to be gentle and calm because you cannot be successful when you are jerking an animal around," she says.

Dairy goats are very curious animals. They like to meet each other. And though it is true that they will taste anything that looks good, they do not eat such things as tin cans. Because a show can be hot and exhausting, the goats like to cuddle up with a friend and take a nap when they can.

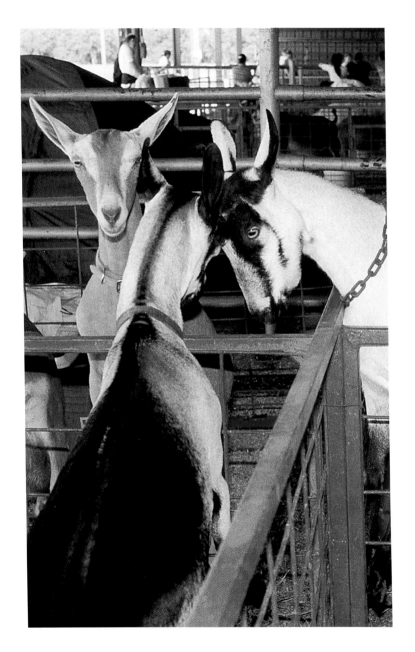

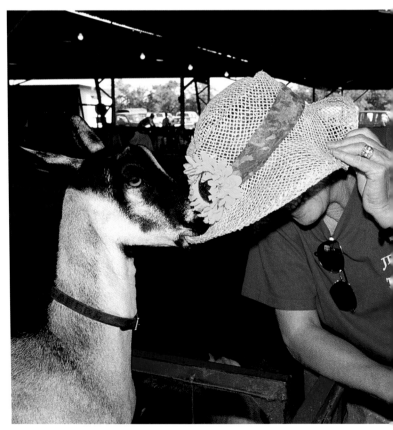

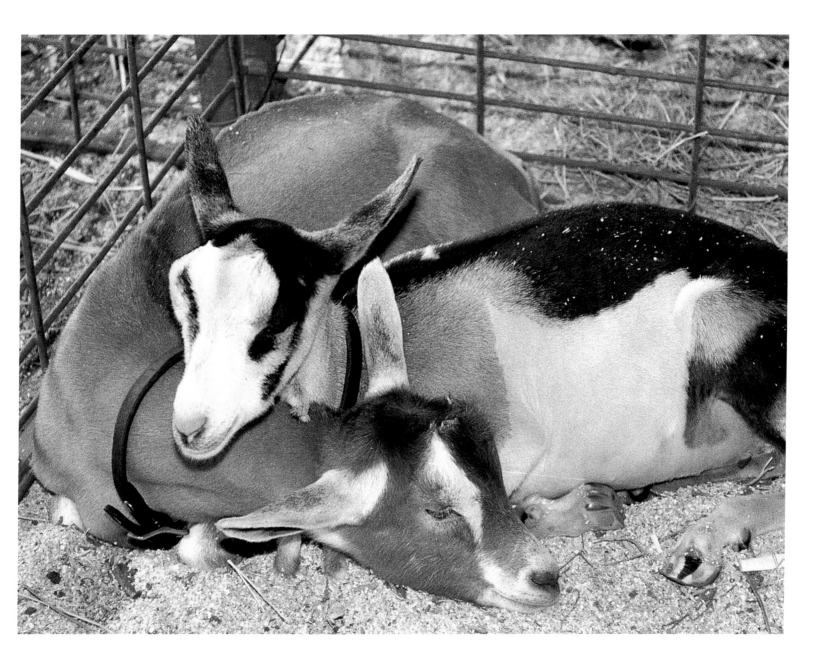

The goats that Sarah and her family own and show are kept in a pasture with a big shady tree. Sarah sighs while she describes the chores that must be done every day. "I milk the goats twice a day, at seven in the morning and seven in the evening. Some goats are greedy, so each one must be fed separately to be sure everyone gets a fair share. Every morning, the older goats are tied to the fence and given a carefully measured amount of feed. Morning and evening, they each get a hay flake [a pressed section of dried hay]. Baby goats are fed milk, and goats up to six months old are given extra feed, so they will grow well," she says.

The goats must be hosed off to stay clean, and in the heat of the summer they are kept clipped and are hosed to stay cool. The goats' hooves must be trimmed every few weeks to keep the hoof from growing too long.

The most exciting day is when the babies are born. Baby goats are called kids. The males are bucks, and the females are does. Deederdee, an Alpine goat, has just had one little buck that Sarah's brother, Charley, has named Tank. The Erwins do not keep male goats. Males are very strong, and they require special fencing and facili-

ties, so Tank will eventually be sold. Sarah and Charley hope that the second kid born that day will be a doe, because it has been promised to Charley so he can show her. They are in luck! One minute after Kate is born, she struggles to stand up.

Immediately after the birth, Sarah sprays disinfectant on the kid to protect her from infection. She then puts Deederdee up on a special platform called a stanchion and milks her. The first milk, called colostrum, is rich and yellow-white and has special nutrients for the kids. The milk is then taken and pasteurized to kill any harmful bacteria, then cooled to feed the babies.

Kate is able to get her first meal immediately. Another doe kidded a few days earlier, and there is pasteurized milk ready to go. Sarah slips a large nipple over a soda bottle and holds Kate while she feeds. "It is hard to get kids to start feeding on the cold, slick nipple," says Sarah as she struggles, "because they want their warm mother. But once they discover what is waiting for them, they suck eagerly."

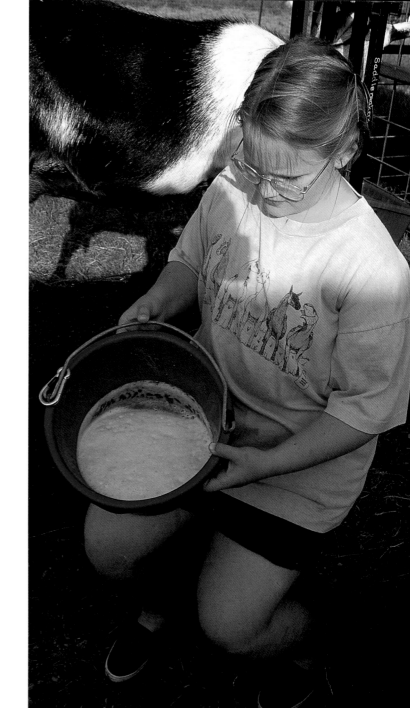

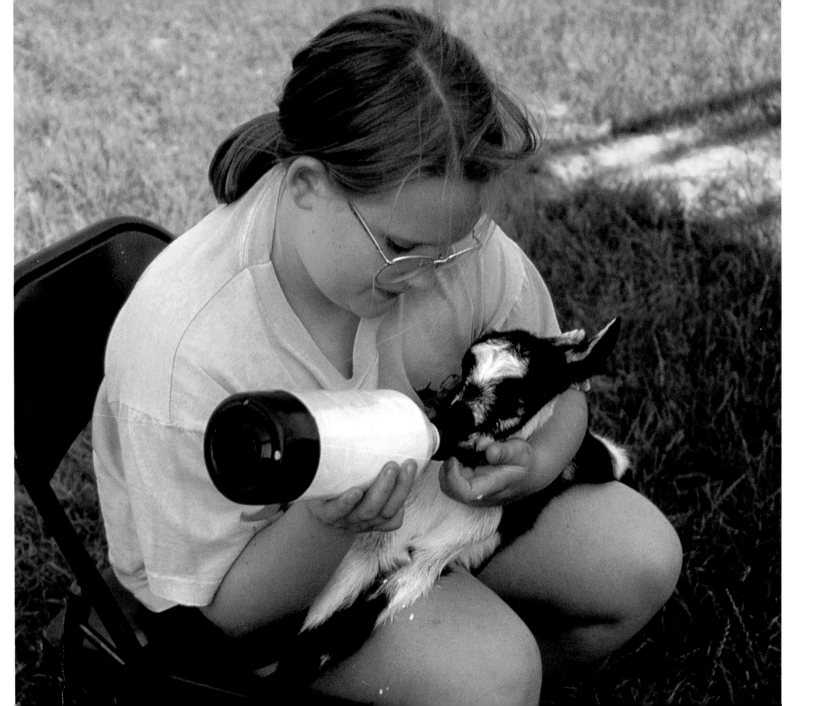

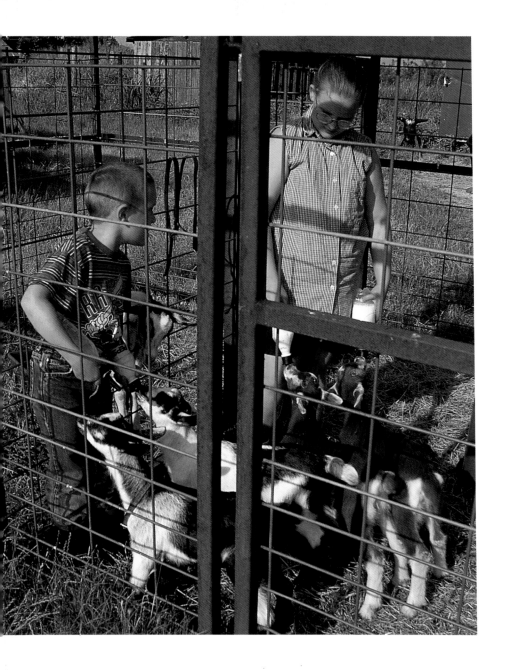

The kids are kept in a separate pen, but their mothers can watch them. Sarah and Charley do the feeding, and now the goats are eager to get to the bottles. In a few days, the mothers will treat the kids like any other goats in the pasture. Sarah and Charley have become their mamas. They will bottle feed the kids for three to four months.

Sarah starts working with the kids when they are only a few weeks old. "At first, they pull at the lead and run around like any baby. They have to be taught to walk with a collar and lead, which they must wear when they are being judged at a show," Sarah explains. It takes patience, but the more Sarah works with her animals, the better behaved they are and the more skills she herself develops in showing the animals.

About a week before a show, the goats will be washed and clipped. That gives a bit of time for any clipping mistakes to grow out before the show. The night before the show, the goats are rewashed, and any last-minute clipping is done. Many items must be taken to the show. There must be buckets for water and feed, a stanchion for milking and clipping, hay racks, a show box with all the necessary tools, towels, goat coats in the winter and a

fan in the summer, and white clothes for the show ring. Sarah shows dairy goats, so she must be dressed in white when she competes. The dairy industry insists that the image of purity be represented by white clothing at any stock event.

It is October and time for the State Fair of Texas. The Erwin family moves into an extra pen next to their goats, and they spend two nights in sleeping bags in the cold. Mrs. Erwin says, "We have to take care of our animals, so we put up with the discomfort. We have a good time with our friends, who are also staying over."

Even though the Erwins will be showing their animals for three days, there are long periods of time when they do not have to be in the arena. All contestants in the stock show get special T-shirts, and there is time to walk around the fair to see the other events. Sarah, Charley, and their sister Molly even meet Big Tex and have their picture taken with him.

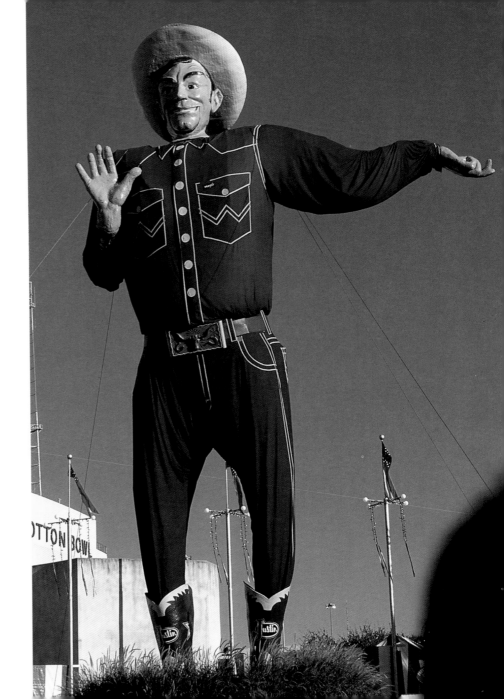

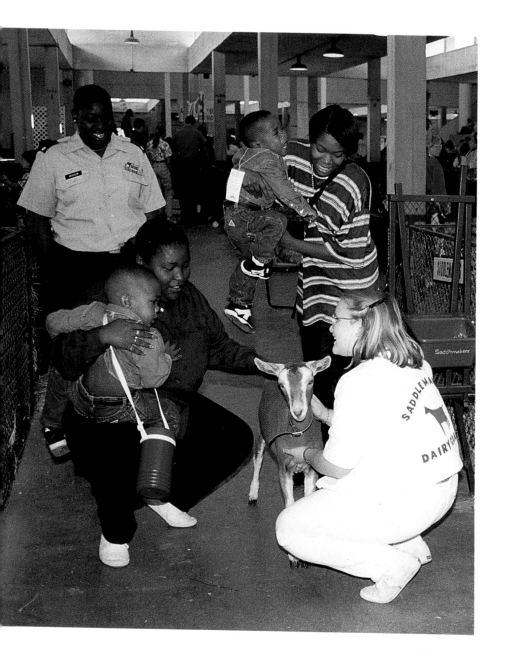

One purpose of a stock show is to provide information to the public about a breed of animal. Sarah is very knowledgeable about her goats, and she spends a great deal of time with one of her animals outside its pen, so visitors can touch it and she can answer their questions. "It is also important to keep your environment attractive and clean. Judges watch throughout the show to see if we keep our exhibit and ourselves neat and if we are friendly to people," Sarah says. The Erwin family is delighted when they are awarded first prize and a banner for their herdsmanship.

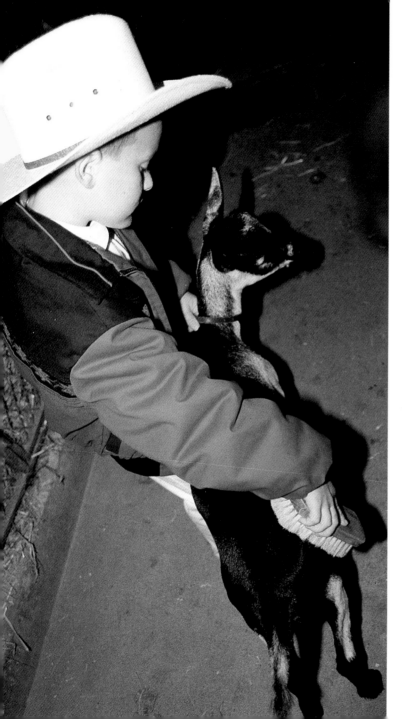

Charley shows his Alpine junior doe, Kate, for the first time at the State Fair of Texas. He grooms her carefully for the appearance, and Kate wins first place for her class. The judge believes Kate has potential to be a good milker.

In January, the Erwins go to the Southwestern Exposition and Livestock Show in Fort Worth. Once again, they camp out in a stall and take their sleeping bags, food, and books and games for entertainment. There is little privacy, and a makeshift dressing room must be created so they can change into their white clothes when it is time to go into the ring.

The barn is vibrating with sound. Goats *baa* all day and night; Nubians are the loudest. Kids are born at the stock show and become the center of attention. There is almost nothing sweeter than a

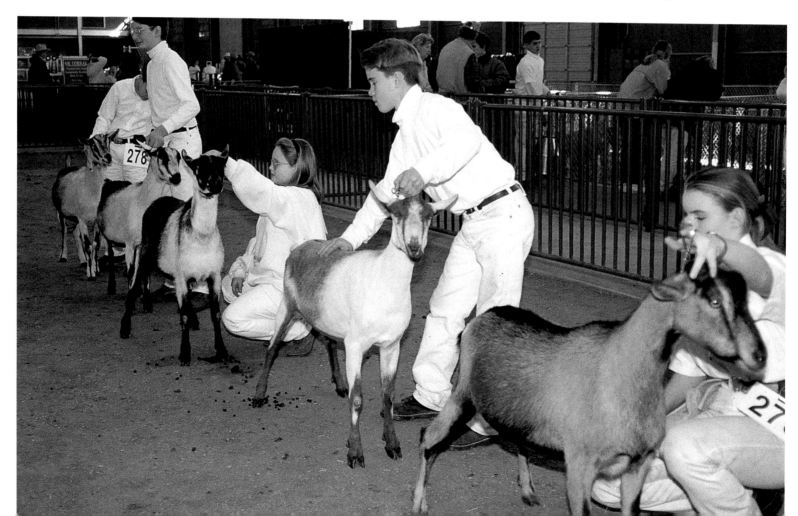

baby goat. Announcements are made over the loudspeaker, and throngs of people come through the barn. It is an exciting place to be.

Competition is very keen at this large stock show. Sarah must set up her goat in the proper way. The front legs are straight down and the back legs are spread slightly, so that a string dropped from the tail would touch the hock on the back of the leg. Sarah has rehearsed this with her goats many times. "I always practice with the rest of our herd around, so my goat doesn't get distracted by the confusion in the ring," she says. When they are asked to lead their goats around, contestants must keep their eyes on the judge at all times and always be on the opposite side of their animals from the judge. The judge will frequently ask questions about the goats, so it is important for Sarah to study the breed she is showing.

Sarah, Molly, and two friends from their 4-H club, Carrie and Casie Abney, have studied so well that they participate together as a dairy goat judging team. Each team must judge several classes (junior does and milkers) of goats. There are four goats in each class, and the judging team must rank them from one to four on dairy character. Their rankings are compared to those prepared by an American Dairy Goat Association judge. The Erwin/Abney team jump up and down when they receive the second place rosette for their judging ability.

The Erwins plan to maintain a herd of five or six adult goats. As kids are born, the family will keep the best does and sell the others. Sarah expresses her feelings about showing her animals: "Sports are fun, but you have to depend on others. When you are showing animals, it is all your responsibility."

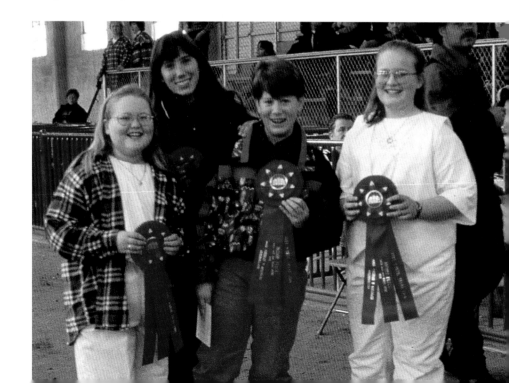

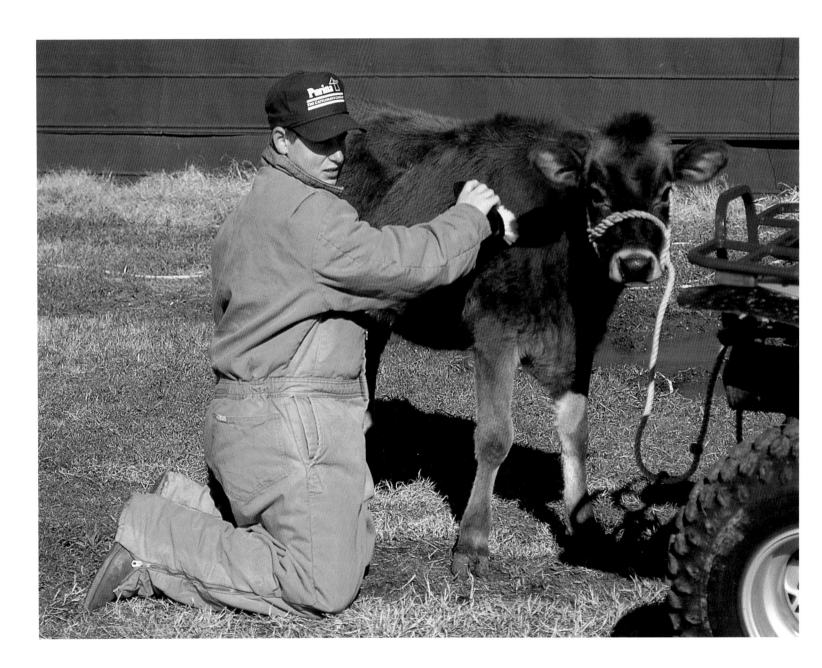

Daniel Simpson

DANIEL SIMPSON is a member of the Future Farmers of America and comes from a family that is in the dairy business. "Most FFA members do not show dairy heifers, because they can only keep them until they become cows. Then they have to sell them to someone who can milk the cows regularly," Daniel says.

Daniel hopes to become a farmer, and he plans to go to college to study to be a good one. Daniel's grandfather began by raising Jersey cows. His cow Patience was the first Jersey to produce more than twenty thousand pounds of milk in one year. "Milk is produced in bulk and weighed in tanks, so it is measured by pounds rather than by gallons," Daniel explains. Patience set the national record for milk production for a three-year-old and was also named National Grand Champion. Daniel's uncle now has the herd, and Daniel is allowed to keep his cows at his uncle's so that they can be milked.

But when Daniel gets a heifer, he is responsible for raising it. A heifer is expensive, costing as much as two thousand dollars, and there is the cost of feed added to that. "I give my heifer a high protein feed in the morning and in the evening and make sure that it has a salt lick and plenty of water. The heifer either stays in its pen or is put out to graze on the winter wheat," he says. "In the South, winter wheat can be planted in the fall when there is mostly grass. The cows can feed on it until spring, when the wheat heads begin to form."

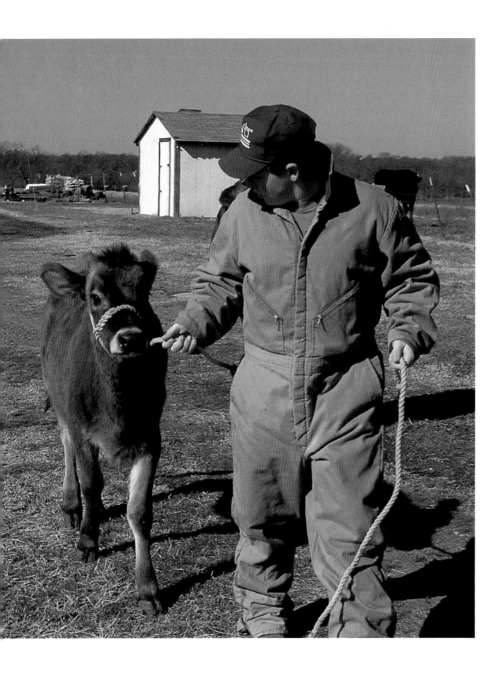

After school, Daniel practices with his heifer every day, getting it used to being led. The more he trains with it, the better behaved the heifer will be when it is in the show ring. In junior showmanship, the judge looks to see how the child has worked with the animal, whether questions about the date of birth and breeding lines can be answered, and whether the youth can lead the animal.

"In an open show, there is no age limit for participation, and in 4-H junior shows, the contestant must be at least eight to take part. But since heifers weigh three hundred pounds or more and, like any baby, might do the unexpected, the child must be large enough to manage the animal," Daniel's mother explains.

It is February and time for the dairy cattle to be exhibited at the Southwestern Exposition and Livestock Show in Fort Worth. Daniel has to be at the stock barn by four o'clock in the morning to get his heifer and cow ready for showing. These animals are not related but have been selected for their outstanding breed characteristics.

The Simpsons hire a professional to clip their cows, as it takes talent to get the job done just right. The cow is shaggy with its heavy winter coat, and the groomer gives it a burr haircut, leaving only one-half inch of hair. A judge is looking for a straight back on a Jersey cow, so the hair must be carefully trimmed along the spine to form a straight line.

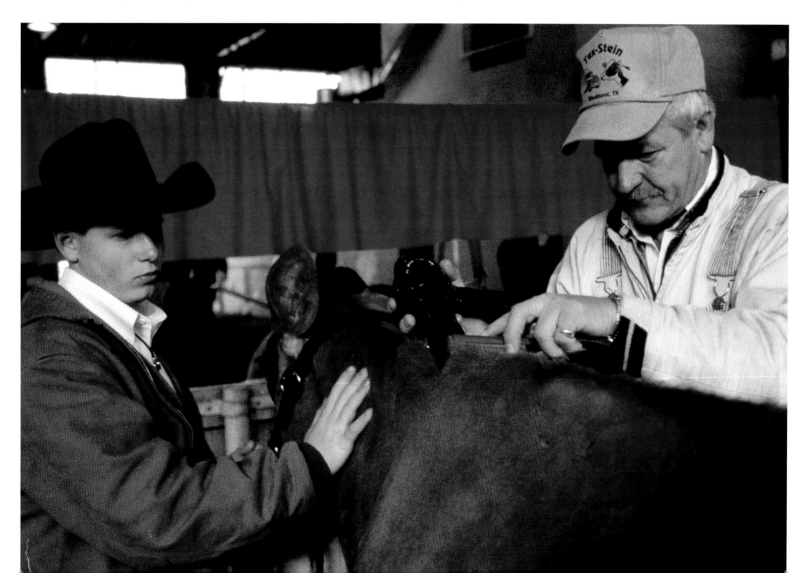

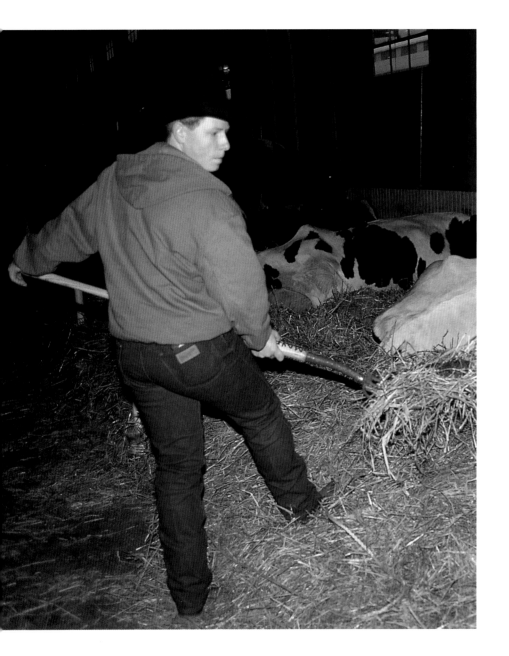

February can be very cold in Texas, so blankets to throw over the cows are kept handy. The animals stay inside in the barn when they return home, until their hair grows out again. Daniel is responsible for the area around his family's cows, and he has to be ready with a pitchfork to pick up waste immediately. "A barn filled with animals can be smelly, so everyone works hard to keep the place clean," he says.

Raising and showing animals is truly a family affair, and Daniel's father and uncle help him with some of the many things that must be done to get a cow or heifer ready for showing. The animal must be washed and brushed, the ears cleaned, and the tail brushed out. The hooves are trimmed and filed, cleaned of all muck, and then spray-painted black with a special glossy show paint. "Because a Jersey cow is the color of cinnamon, a bottle of cinnamon is always in the show box to have handy to rub over a scar or blemish. This is like using makeup in a beauty contest," Mr. Simpson says.

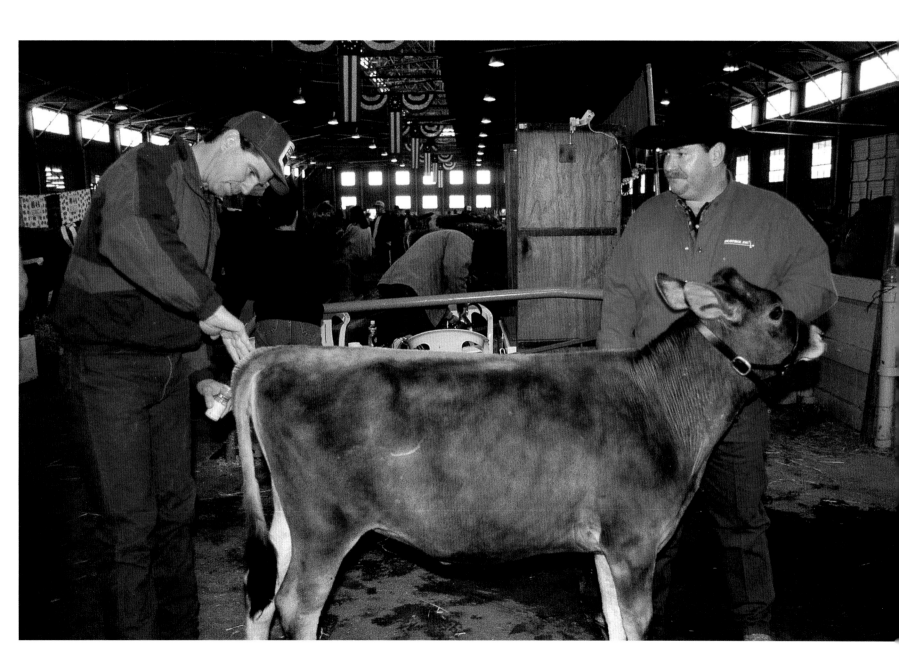

The dairy barn is dusty, and Daniel's housekeeping chores can be messy so he changes into his white clothes just before his event. Then, Mrs. Simpson works with him to memorize the facts about each animal he is showing, in case the judge asks him questions in the ring. Each animal must have registration papers and an ear tattoo. These are checked to be sure that the contestant is really showing the same animal at different stock shows all year long. As a member of his school's FFA chapter, Daniel is evaluated on the progress his animal makes during the year.

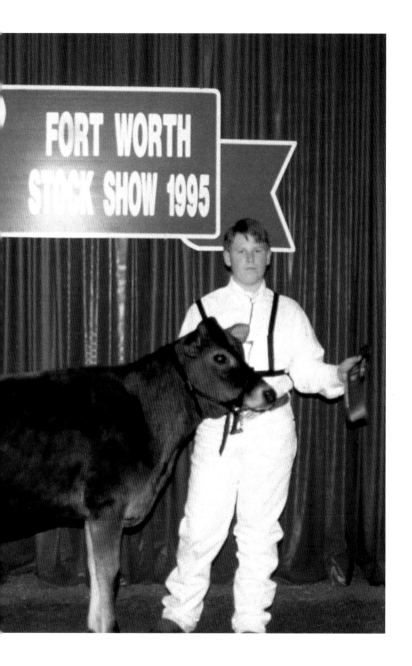

There is always a great deal of time spent waiting at a stock show because different ages and breeds of animals are shown throughout the day. This year, the wait is worth it. Daniel wins many awards, including a Blue Ribbon Group Third Place for his heifer. And he is also awarded Blue Ribbon Group First Place, Purple Ribbon Group First Place, and Reserve Grand Champion for his four-year-old cow. It is typical to see winning ribbons sticking out of a back pocket. It is a cool way to show what you have won.

Daniel's awards are an example of the levels of prizes that an animal can win. At a sanctioned show (one approved by the national organization and having licensed judges), the winning animals are registered with the national organization for determining state and national rankings. Animals are first judged according to their breed and age class, so they are competing against similar animals. The winner is given a blue ribbon, and other ribbons are given to lower ranked but quality animals. If there are unusually excellent animals, they can be awarded a purple ribbon as well as a blue ribbon. All of the first-place winners of a breed (in Daniel's case, Jerseys) are then judged to select the Grand Champion for the breed. The Reserve Grand Champion is selected from the rest of the first-place winners of the breed, plus the second-place winner in the class of the Grand Champion. Best in Show is selected from all Grand Champions of all breeds of a type of animal.

By the middle of summer, Daniel's heifer has grown, and Daniel now works with it weekly to keep the animal used to being led, as well as to improve his own showmanship skills. Daniel has won quite a few awards since February, even though there aren't many stock shows that include dairy cattle. Daniel also explains that you can't get attached to your heifer, as you would with a pet. "A heifer is like a truck. You take care of it, but if it doesn't perform the way you think it should, you have to get another one," he states.

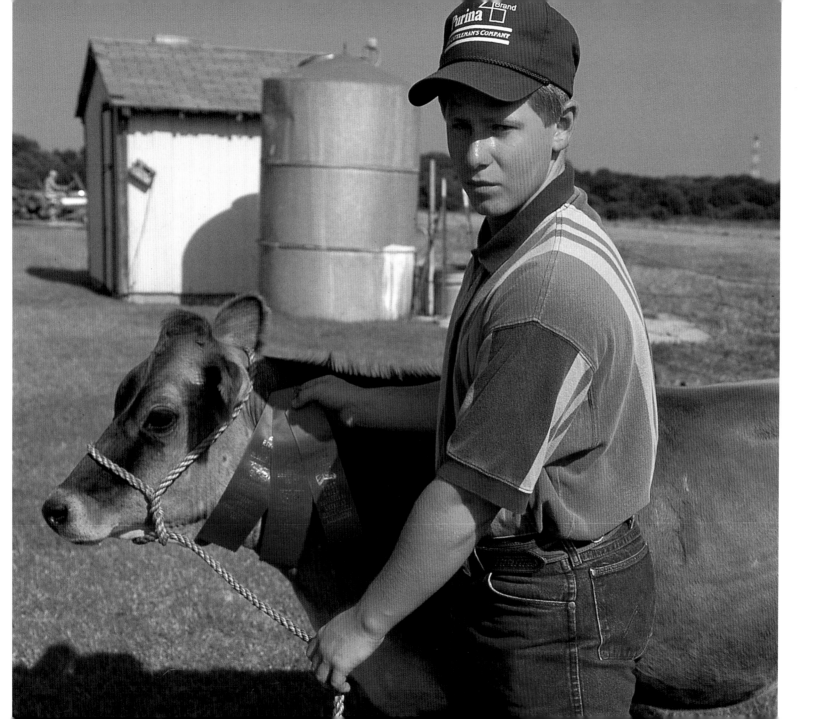

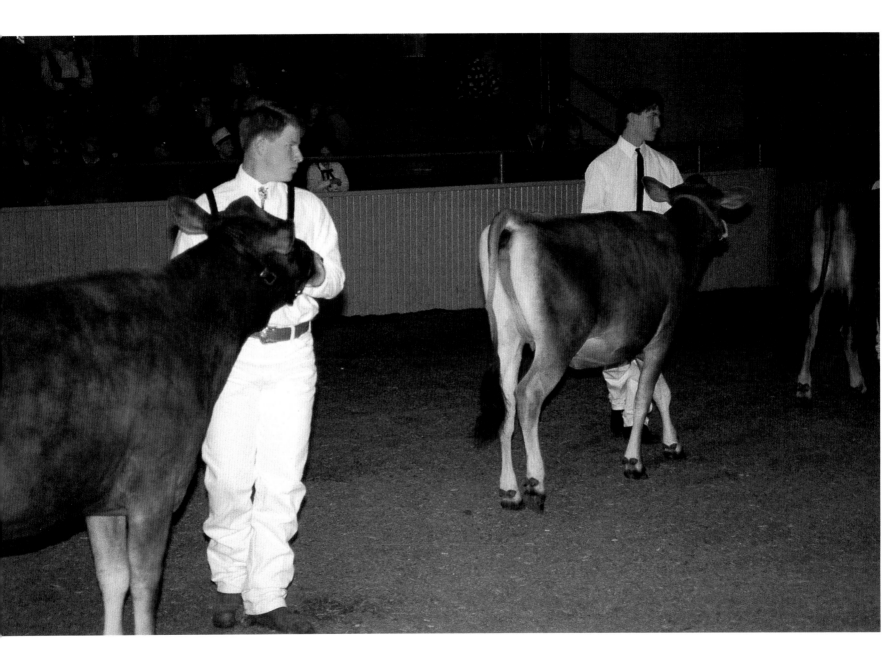

Once again, it is February and time for the Fort Worth stock show, which is celebrating its centennial year. During the year since the last show, Daniel has been working on his showmanship abilities. "When you show dairy cows, you have to walk backwards and use the halter for control, and for adjusting the head and feet. You have to walk very slowly, always keeping your eyes on the judge. It sure would be easy to fall over backwards if you weren't paying attention," he says with a grin. Daniel's practice after school has paid off, and he wins Second Place Showmanship, recognized by the Texas Jersey Cattle Club. It has been a good year for Daniel and his animals, and there will be more to come.

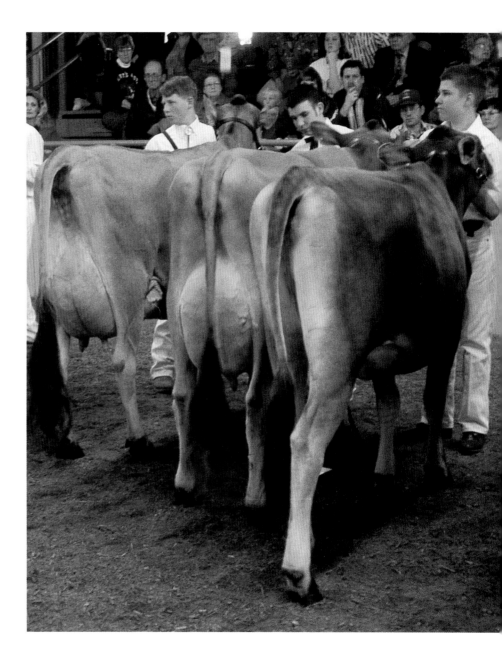

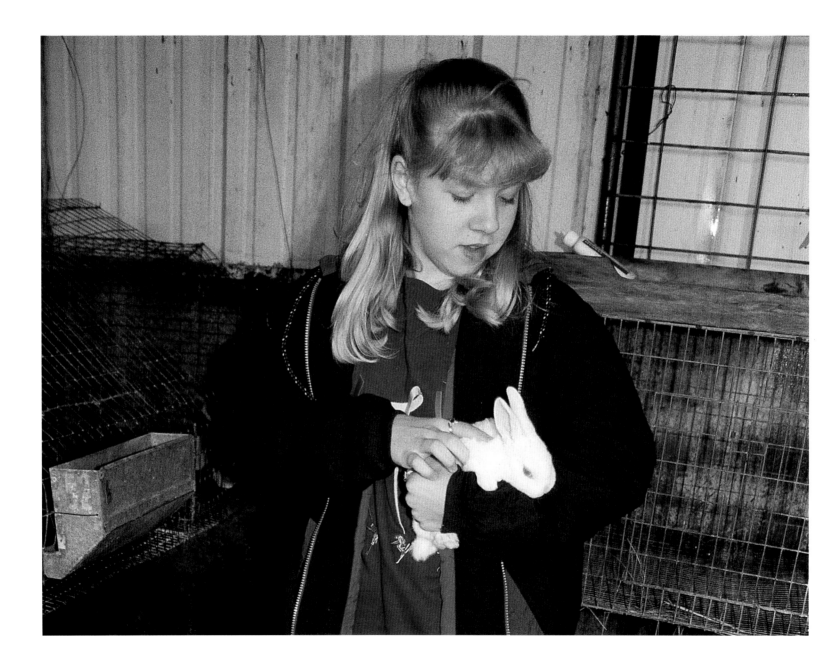

Sarah Griffeth

SARAH GRIFFETH is a member of the Bluebonnet Rabbit 4-H Club and the Sanger, Texas, FFA. The rabbit club meets once a month during the school year. "We talk about upcoming shows, learn what a judge is looking for, study for tests that are given at the stock shows, and observe a demonstration. We become friends and see each other often at stock shows," says Sarah.

"Sarah and her sister Sam [Samantha] have had many animals, among them goats, sheep, hamsters, and rabbits. When Sarah won a blue ribbon with her first rabbit, she just lit up all over. It was wonderful for her self-esteem," says Mrs. Griffeth. "Children can't all be the best cheerleader or athlete. But if they work hard enough, they can be successful in raising winning animals and excelling in showmanship."

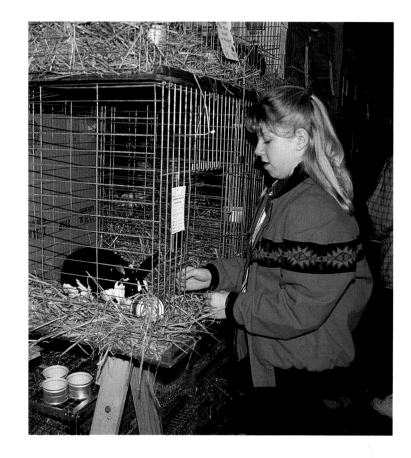

Sarah keeps some of her rabbits in a barn at her home and others on her father's farm. When it is cold, it is necessary to protect the rabbits. Sarah puts hay in their pens for feed and for burrowing into. She also uses a heating lamp. If there are baby rabbits, the mother will pull out some of her own fur to keep them warm.

Rabbits usually have three litters a year and produce three to seven babies per litter. "If a rabbit has as many as twelve babies, some of the babies have to be fostered by another mother rabbit," Sarah's father explains. Watching a nest of baby rabbits is like watching a pan of popcorn with the lid off. Every few seconds, a baby twitches, and then, they all leap into the air and settle back down. "It is possible that the babies think that someone is getting some milk, so they all leap to find their mother," Mr. Griffeth suggests. "One important thing that happens after this movement is that the rabbits on the outside might have a chance to snuggle into the middle. This way the babies take turns being the warmest in the nest." Baby rabbits are very small. A three-day-old rabbit is almost lost in a man's hands. Rabbits born in the summer have longer ears because they sweat through their ears.

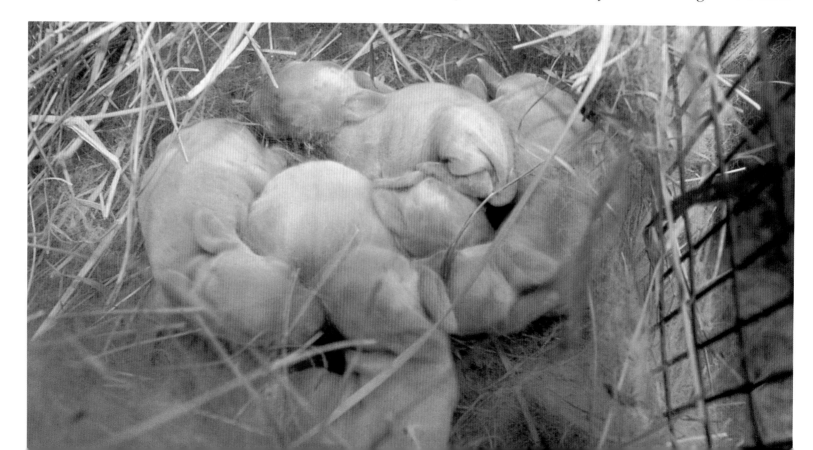

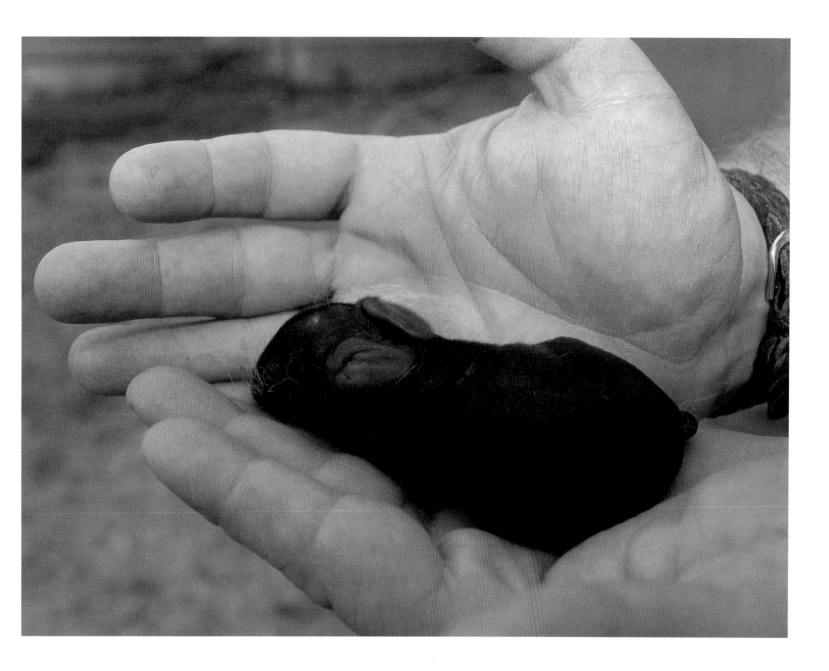

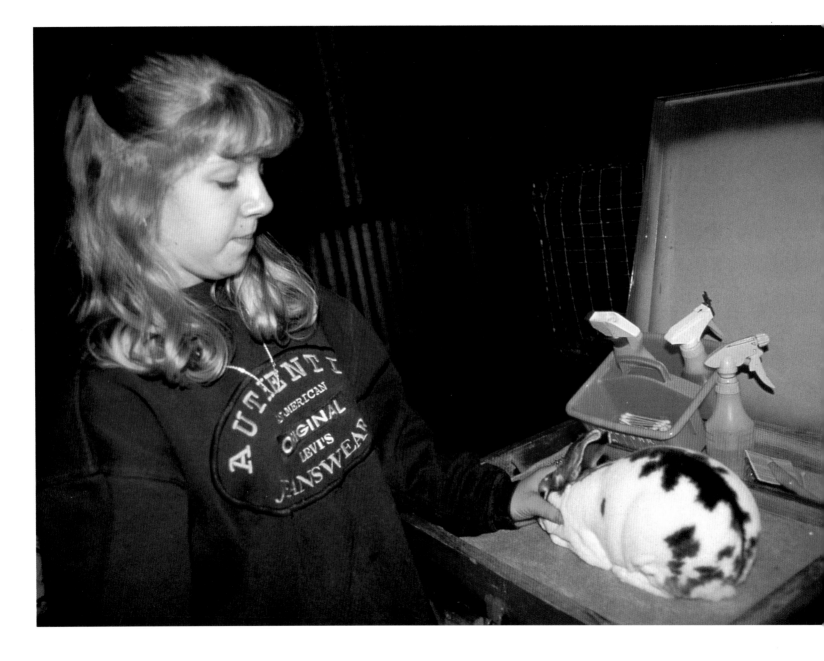

The rabbits that Sarah shows are called Rex or Mini-Rex. There are fifteen varieties, and Sarah shows black, white, castor (reddish brown), broken castor (brown and white), and broken black (black and white). When selecting the rabbits she is going to take to a show, Sarah looks for good body type and thick fur.

"During a show, it is important to keep the pen supplied with feed and water. The rabbits often upset their cups, and they have to be refilled. If it is cold, the pen must be filled with plenty of hay for warmth. Before it is shown, the animal must be groomed on the grooming stand. The ears are cleaned, the fur brushed and sprayed, and the animal is checked for any faults," says Sarah.

Owners must be available to talk to interested visitors, telling them about the breeds of rabbits and how they are cared for. Because there are more babies born than can be shown, this is also an opportunity to sell animals. The Griffeths display their awards near their rabbits, which is a sign to potential buyers that these are quality animals.

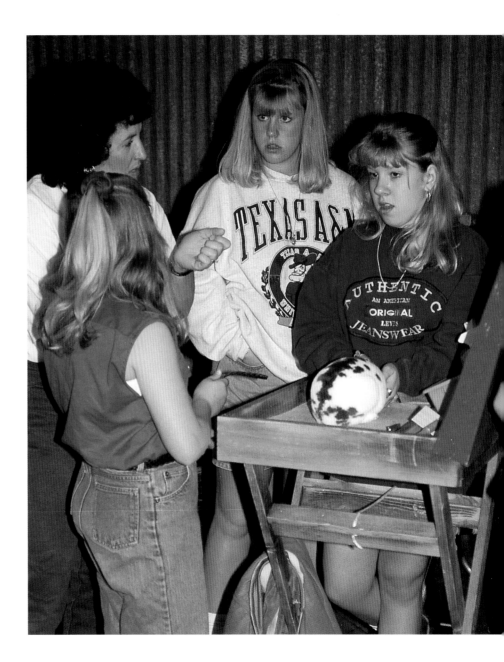

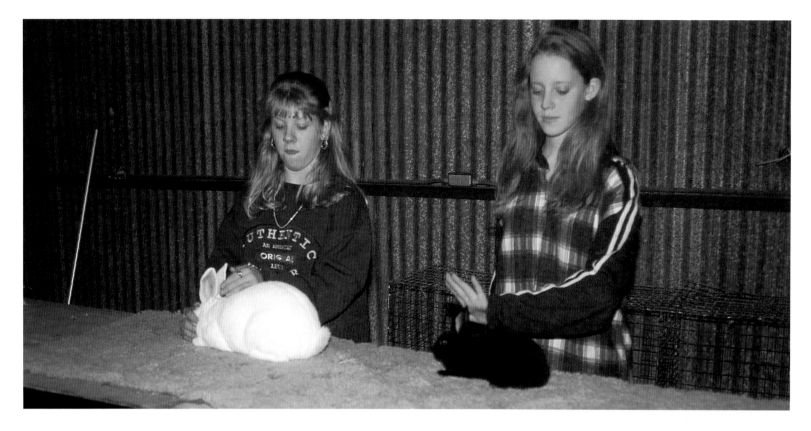

Showmanship is an important part of the event. Children are paired off, and a judge asks them questions from a sheet. The contestants must display their knowledge of the animal's body parts as well as be able to put the animal into the requested position. After all contestants have had an opportunity to answer the same questions, the showmanship prizes are awarded.

When it is time for the animal to be examined for its quality, the contestants place their rabbits in a judging pen, which is on tables set up in a square with the judges inside. The wire cage opens on both sides. The contestants put the animals in one side, and the judge removes them from the other side. There is a long list of features to be evaluated.

"I check to see if there are ear mites and whether the teeth are straight and healthy. A rabbit must have five toenails on each of its front feet and four toenails on each of its hind feet. The tail must not be broken, and both eyes must be the same color. The body type should have strong shoulders and no bones sticking out, and the fur should be thick and healthy," a judge at the North Texas State Fair explains.

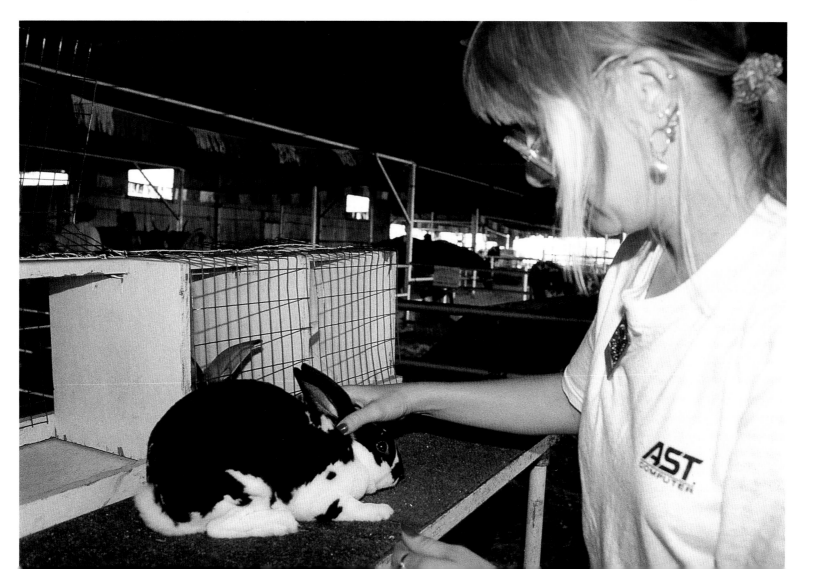

Any prize money the Griffeths win is used for buying new rabbits and feed and for their travel to stock shows. They spend many weekends traveling all over Texas and nearby states showing their animals. Mrs. Griffeth says, "This brings our family close together. The feeding, care, and travel—everyone does their share to make it work." The Griffeths have a trailer to transport their animals and equipment to shows.

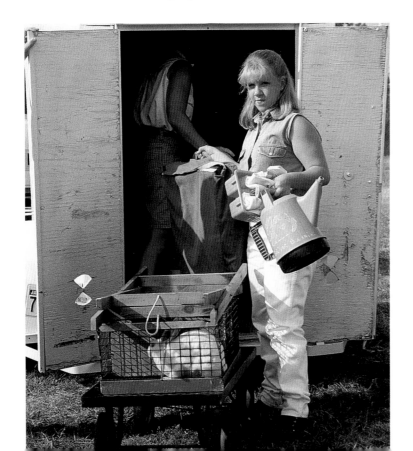

Sam is beginning to get more involved in showing, and she has two Flemish Giants. She, too, must learn how to prepare her rabbits. Waiting periods are often filled by taking care of the animals, and Sam has time to give her rabbits some affection.

The competition at the State Fair of Texas is huge. Because rabbits are small and easier to raise than many other animals, there are hundreds of entries in the show. Sometimes it is even hard to get near your own animal in its pen because there are so many people milling around. Sarah is a pro by now, however, and she wins several ribbons. Her rabbits win Best of Variety, Best Opposite of Variety, and Best of Breed. If the Best of Variety is a female, the best Opposite of Variety is a male, and vice versa.

Sarah sums up her feelings about raising and showing rabbits this way: "I have to work hard all year round taking care of my rabbits. I'm often hot and sweaty or freezing cold at shows. We have to get up so early in the morning to drive to a show. But at the end of the day, it feels good to have been a success."

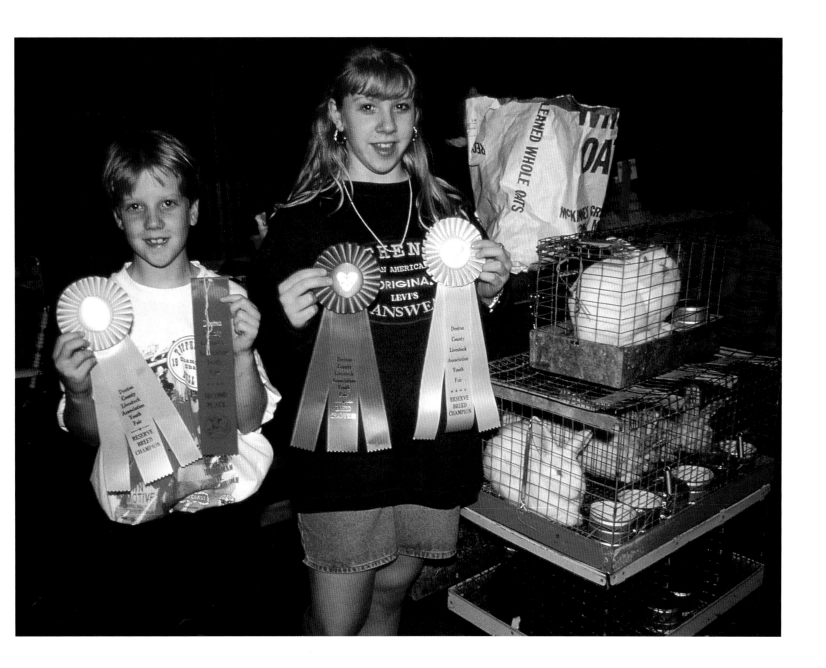

Glossary

The following definitions have specific meanings for this book.

BREED a domestic animal having consistent and recognizable inherited characteristics; e.g., a Jersey cow

CLASS a group of animals of the same breed and age

COLOSTRUM the first milk secreted immediately after childbirth

COW a mature female bovine that has had a calf

EAR MITES a tiny arachnid found in the ear of an animal

4-H an organization for youth ages nine (or in third grade) to nineteen, affiliated with the United States Agricultural Department and county extension agencies; designed to develop leadership and life skills

FUTURE FARMERS OF AMERICA (FFA) an organization for youth in high school; designed to develop skills for sound farming

HEIFER a female bovine, before she has had a calf

HOCK the tarsal joint of the rear leg of a four-legged animal

JUNIOR DOE a female goat, before she has had a kid

MILKER a mature goat that has had a kid

PASTEURIZE use heat to destroy disease-bearing bacteria in milk

STANCHION a portable platform to put goats on for milking or grooming

TYPE OF ANIMAL a category of animals, e.g., rabbits, goats

Sources of Further Information

American Dairy Goat Association, PO Box 865, Spindale, North Carolina 28160 704-286-3801

Dairy Goat Journal

 Duck Creek Publications, 128 East Lake Street, Lake Mills, Wisconsin 53551

Damerow, Gail. *Your Goats: A Kid's Guide to Raising and Showing.* Pownal, Vermont: Garden Way Publishing, 1993.

FFA New Horizons

 Future Farmers of America, 5632 Mount Vernon Highway, PO Box 15160, Alexandria, Virginia 22309 703-360-3600

Hoard's Dairyman

 W.D. Hoard and Sons Co., 28 Milwaukee Avenue West, Fort Atkinson, Wisconsin 53538

Jersey Journal

 American Jersey Cattle Association, 6486 East Main Street, Reynoldsburg, Ohio 43068

Official Guide to a Progressive Program for Raising Better Rabbits and Cavies (guinea pigs)

 American Rabbit Breeders Association, PO Box 426, Bloomington, Illinois 61702 309-827-6623

Raising Rabbits Successfully. Williamson Publishing Co., Charlotte, Vermont, 1984.

Searles, Nancy. *Your Rabbit: A Kid's Guide to Raising and Showing.* Pownal, Vermont: Storey Communications, Inc., 1992.